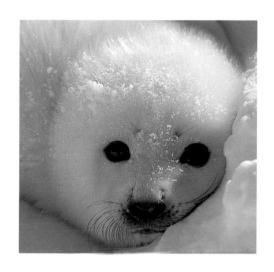

SEAL JOURNEY

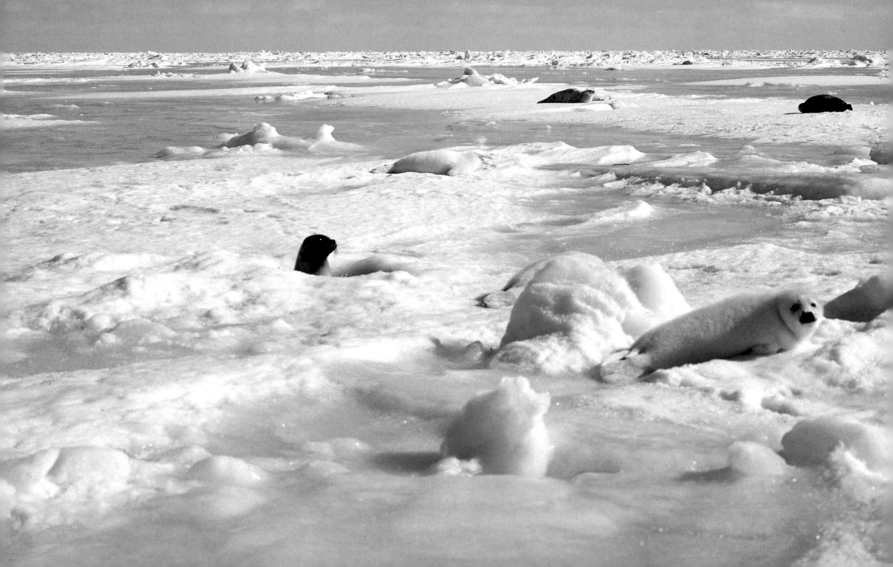

SEAL

By Richard and Jonah Sobol
Photographs by Richard Sobol

JOURNEY

COBBLEHILL BOOKS/Dutton
New York

For Ronnie Mae

Library of Congress Cataloging-in-Publication Data

Sobol, Richard.
 Seal journey / Richard and Jonah Sobol ; photographs by Richard Sobol.
 p. cm.
 Summary: The author/photographer and his eight-year-old son journey to the
ice floes of eastern Canada to observe the thousands of harp seal pups born there
each year.
 ISBN 0-525-65126-8
 1. Harp seal—Canada—Juvenile literature. 2. Harp seal—Canada—
Parturition—Juvenile literature. [1. Harp seal—Infancy. 2. Seals (Animals)—
Infancy.] I. Sobol, Jonah. II. Title.
QL737.P64S63 1993
599.74'8—dc20 92-25974 CIP AC

Published in the United States by Cobblehill Books,
an affiliate of Dutton Children's Books,
a division of Penguin Books USA Inc.
375 Hudson Street, New York, New York 10014

Designed by Charlotte Staub
Printed in Hong Kong First Edition
10 9 8 7 6 5 4 3 2 1

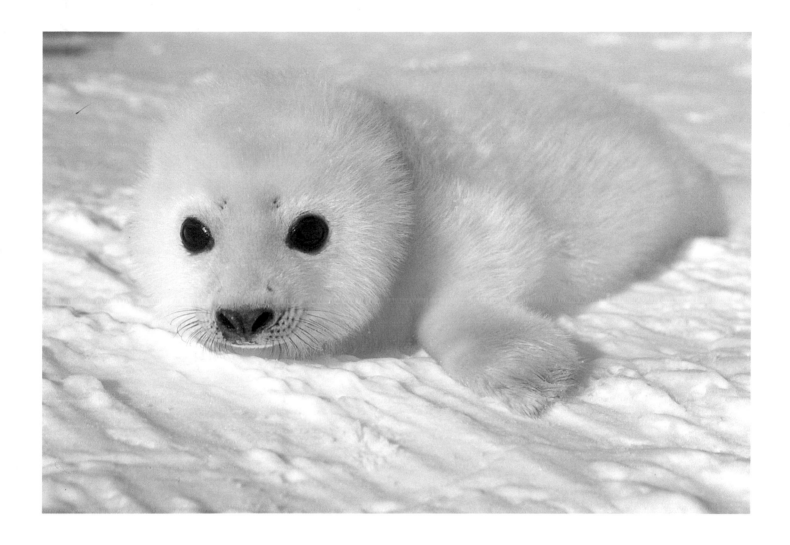

The life cycle of the harp seal is one of the great wonders of nature. Each autumn the seals begin a remarkable journey that carries them over three thousand miles. At a steady flow throughout the winter months, hundreds of thousands of mature harp seals swim through iceberg-filled waters

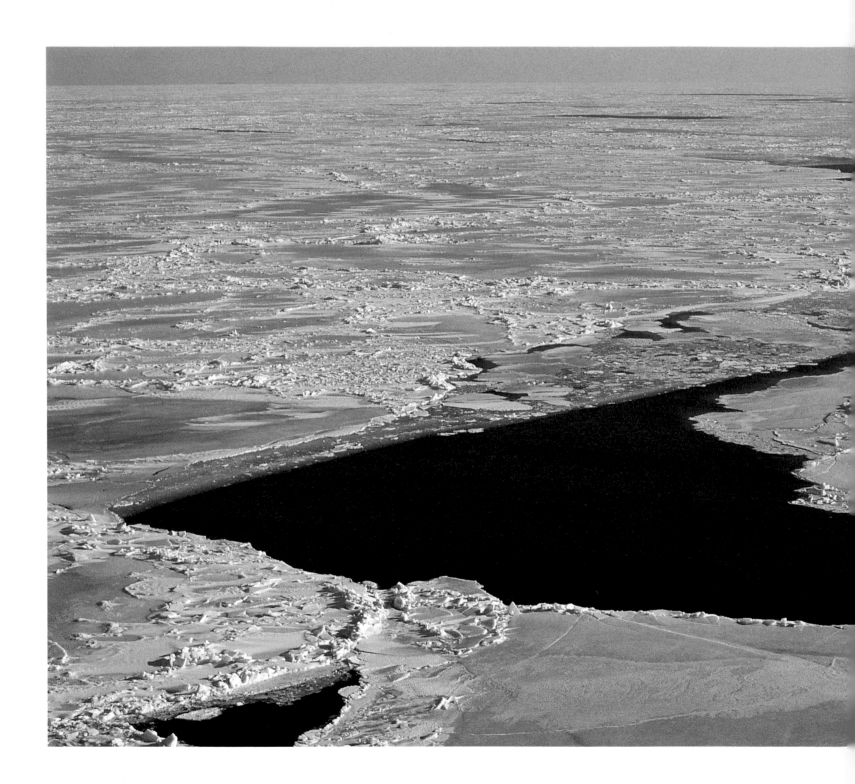

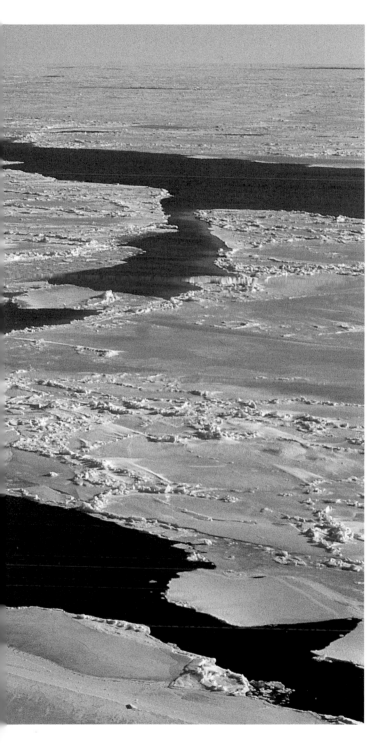

from their summer homes in the northwest Atlantic, just below the North Pole, to the solid ice packs in the Gulf of St. Lawrence in eastern Canada. Once they reach the great sheets of winter ice, each female harp seal will claim her own space on which to give birth to a single pup. Thousands upon thousands of harp seal pups, more than anyone could ever count, are born and nurtured here each spring, transforming this frozen wilderness into a vast nursery.

At the same time a second breeding population gathers on pack ice in the Barents Sea off the northern coast of Russia, while a third and smaller group comes together east of Greenland.

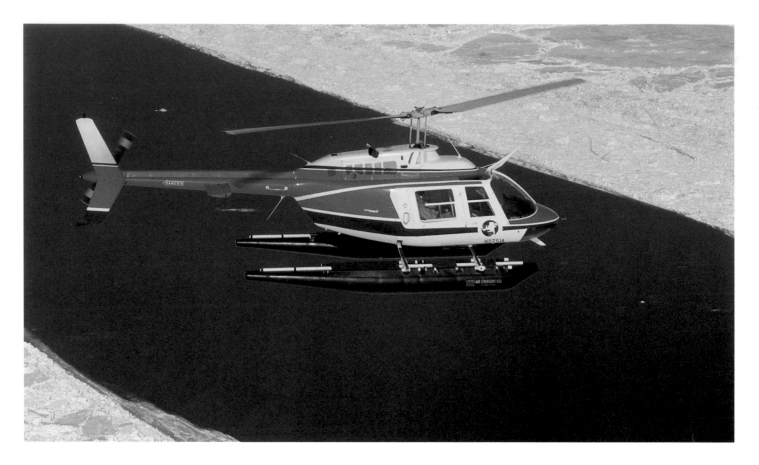

This year I had come to Charlottetown, Prince Edward Island, which is used as a base camp for scientists to observe the newborn harp seal pups. This was the third time that I had made this journey on assignment for a French photo agency. The first trip had been in 1981 when I set out to show the cruelty of the seal hunt that was then taking place. Now I was here to tell the story of the seals' survival and to photograph the beginnings of life out on the ice.

My eight-year-old son, Jonah, had been dreaming of seeing the seals, and I invited him to come along with me. "Can I really come with you?" he said in disbelief when I first asked. After that his questions were endless. "Will I get to see newborn seals?" "How cold will it be?" "How will we get onto the icc?" I answered as many questions as I could until finally I assured him that the best answers would come from his own observations out on the ice.

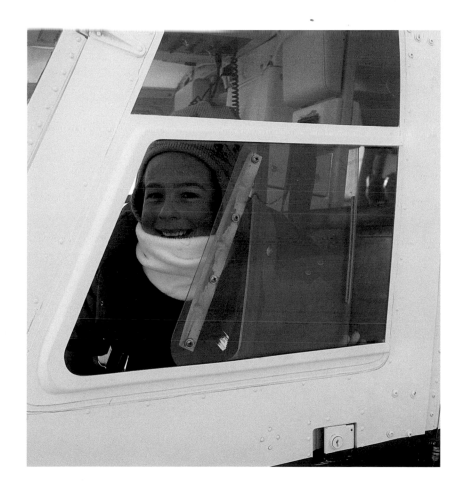

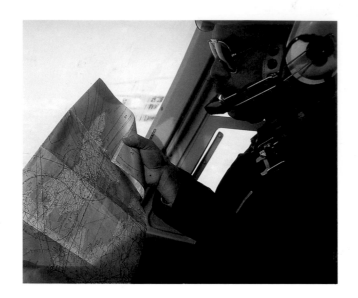

The seal colony was located about a hundred miles north of Prince Edward Island and the only way to reach it was by helicopter. Jonah sat in the front next to the pilot. After we took off, the pilot held up his map, showing Jonah the spot where we would find the seals. The map, though, showed an ocean of blue, not miles and miles of white jagged ice, looking like a moonscape, that we had been flying over all this March morning. The snow-covered farmlands of Prince Edward Island had quickly faded from view. We now flew over wide swatches of packed ice sandwiched between small strips of open water. Searching the horizon, we eagerly waited for our first glimpse of the seals. The pilot smiled as he pointed outside and said, "Look down now, there they are. The seals have returned once again." Below us tiny brown specks dotted the ice, first a few, then more and more, looking like chocolate sprinkles scattered on top of a huge bowl of vanilla ice cream.

As soon as we stepped out of the helicopter, we could hear the soft cries of hungry newborn pups. These were the only sounds that drifted through the stillness of this frozen landscape. It was spring-time but the air was very cold—five degrees below zero. The wind bit into our skin. As we walked

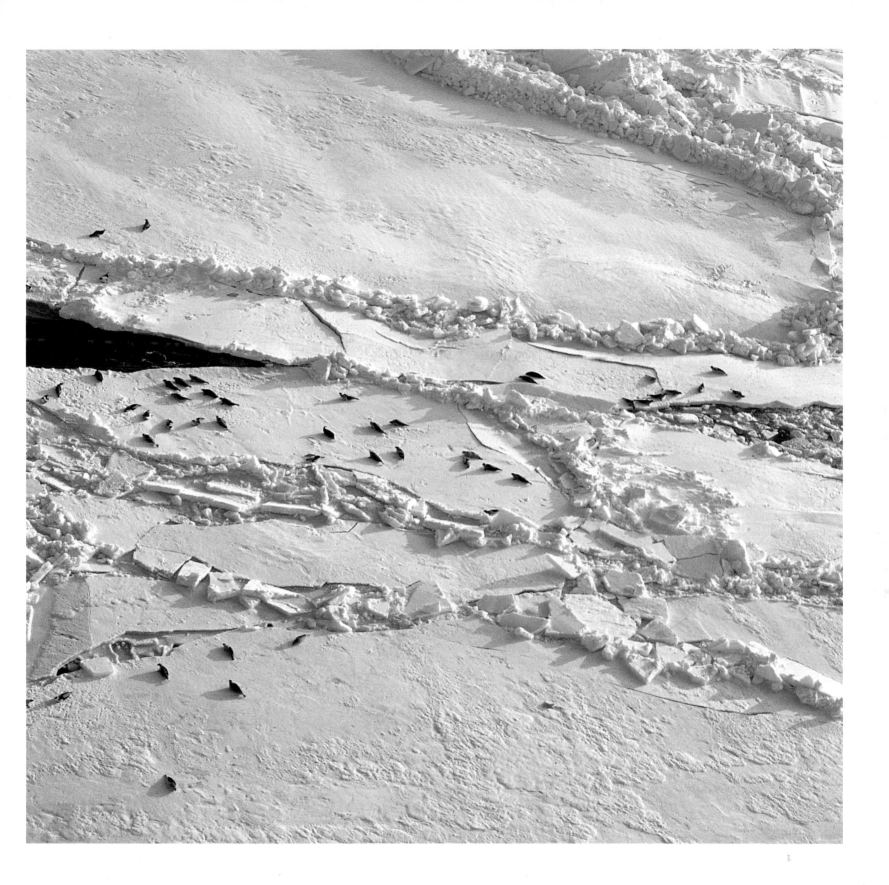

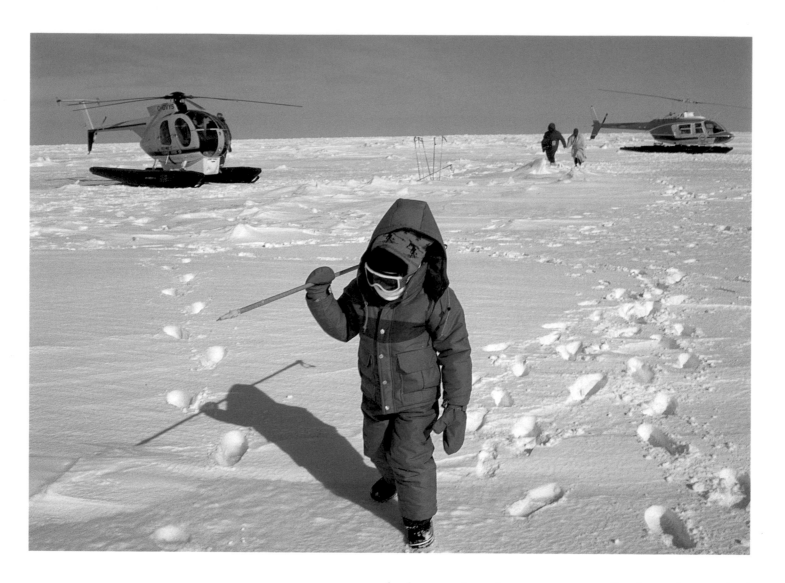

toward the seals, the snow swished and swirled
under our clunky survival boots. We were careful to
avoid the smooth round holes in the ice—bobbing
holes—that the mother seals dive in and out of to
return to the water to feed on small shrimp or fish,
or just to swim.

Seals are great swimmers but, like other mammals, they require air to breathe. They are able to hold their breaths for long periods of time and dive deep into the water. Every few minutes they pop up through bobbing holes onto the ice to fill their lungs with air and to check on their pups.

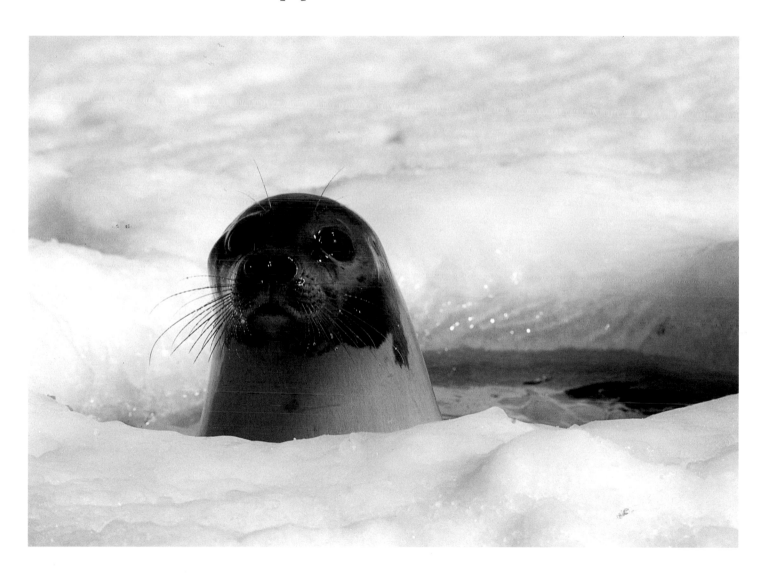

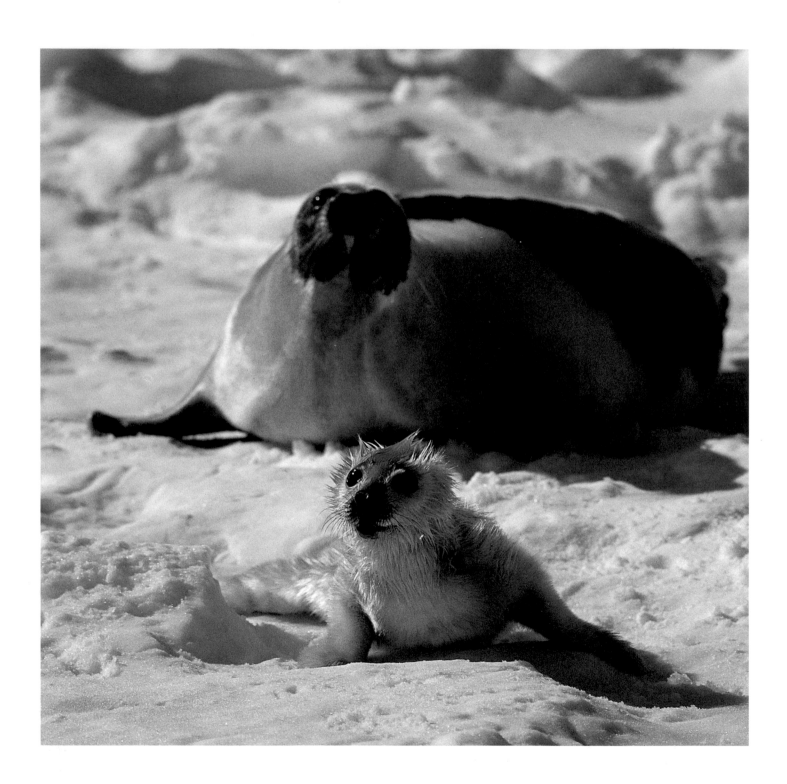

As we walked closer to a small group of seals, we heard a sharp, deep cry, like a cat screeching in the night. We climbed along a large ridge of ice to get a better look. Up ahead, we spotted a female seal twisting one way, then another, again and again. There was a sense of great excitement in her movements and cries. Jonah tugged at my sleeve and pointed to a newborn pup, only minutes old, that was lying beside the mother seal. It was still wet and yellow from its birth. He did not look at all like the cuddly white ball of fur that we were expecting. It will take a day or two in the sun for this birth-stained scraggle to be transformed into a lush baby known as a "whitecoat." Jonah said he felt sorry for

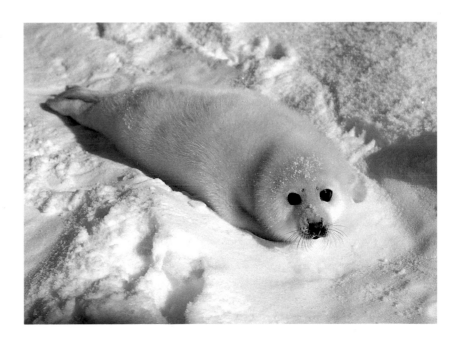

the tiny pup, outside on frozen ice, having just left the warmth of his mother's womb. Now, as the steam rose up from his scruffy, gooey coat the mother moved closer to him, to reassure him and share her warmth. As they nestled together in the warm glow of the sunlight, it was easy to see the dark markings on the mother seal's back. They were indeed the familiar curves of a harp, the musical instrument for which these seals are named.

To survive in this new world, harp seal pups are born with a small amount of baby fat which they immediately start to burn in order to give their bodies heat. But, they need their mothers' milk to

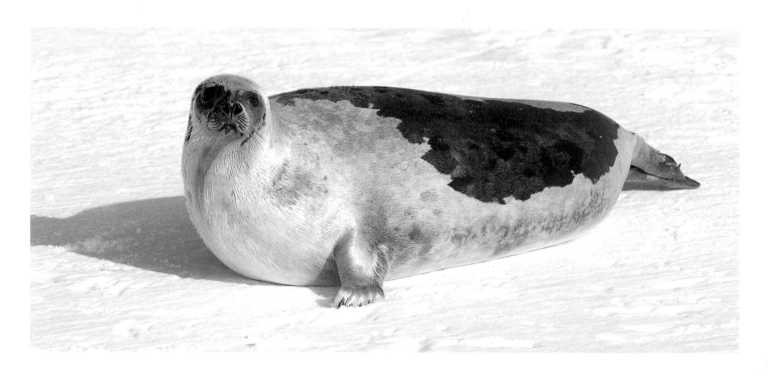

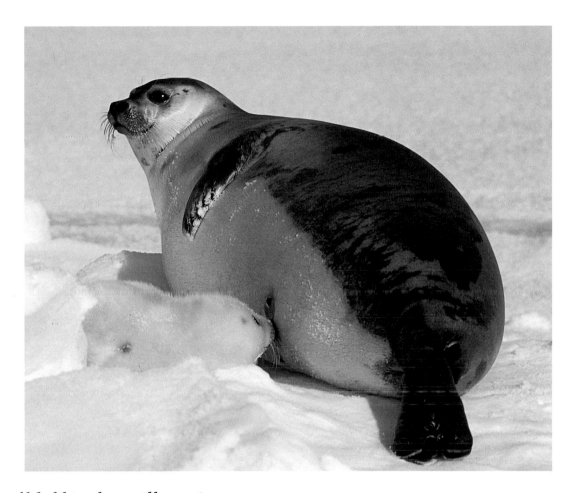

grow the thick layer of blubber that will continue to protect them from the deep freeze that they are born into. We watched with wonder as the mother rolled onto her side, and the pup slid up toward her searching for the milk. The pup lay perfectly still, nursing without a break for ten minutes, as he would need to do five or six times each day.

The mother seals' milk is ten times richer than either cows' or humans' milk, and a well-fed pup

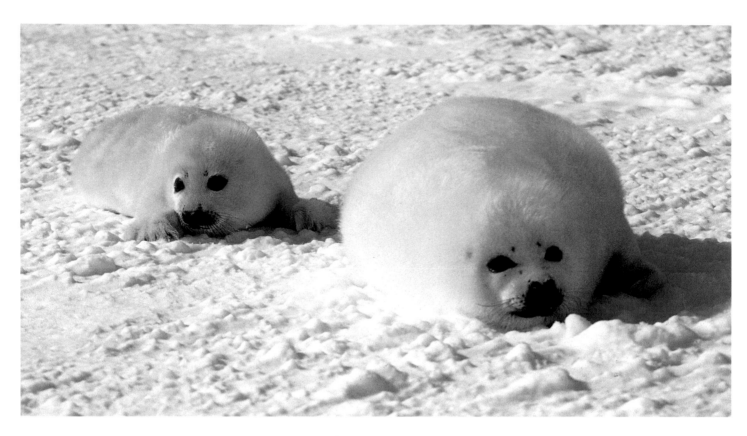

will grow from twenty pounds at birth to almost eighty pounds by the time he is weaned at twelve days old.

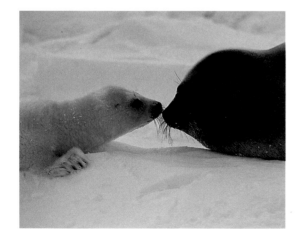

Before the pup finished nursing, the mother rubbed noses with him. This "kiss of recognition" was her way of familiarizing herself with the smell of her pup. A mother seal is often surrounded by dozens of pups and she must be able to identify her own by its unique scent or it will not survive. She has only enough milk for one pup and she will only nurse her very own.

A few feet away we saw what appeared to be a mother seal giving her pup a swimming lesson. The mother nudged him toward the water, while the pup squealed and squealed. And then the pup was in the water, floating and bobbing like a little cork.

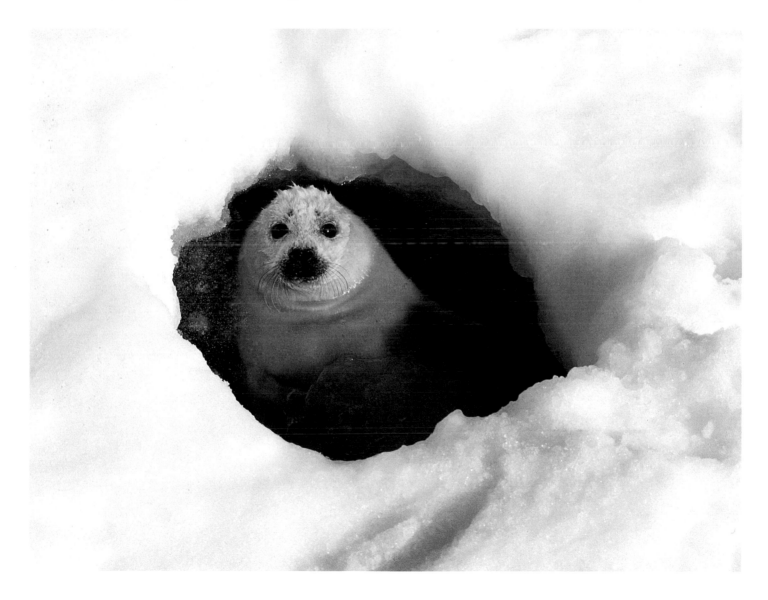

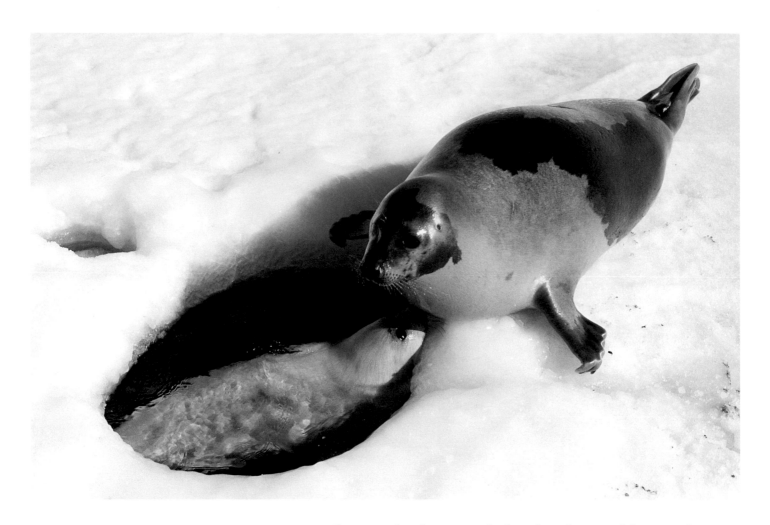

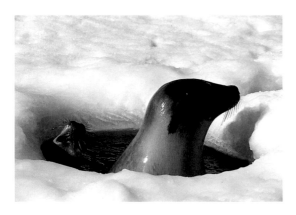

The pup had so much fat that he couldn't sink. "It's like he is wearing a life jacket," Jonah said, as the mother jumped in the water too. It was almost as if they were playing a game of tag. First the mother disappeared under the water. A few seconds later, she popped up in a different place. The pup squirmed and paddled to catch up to her. Then they rubbed noses.

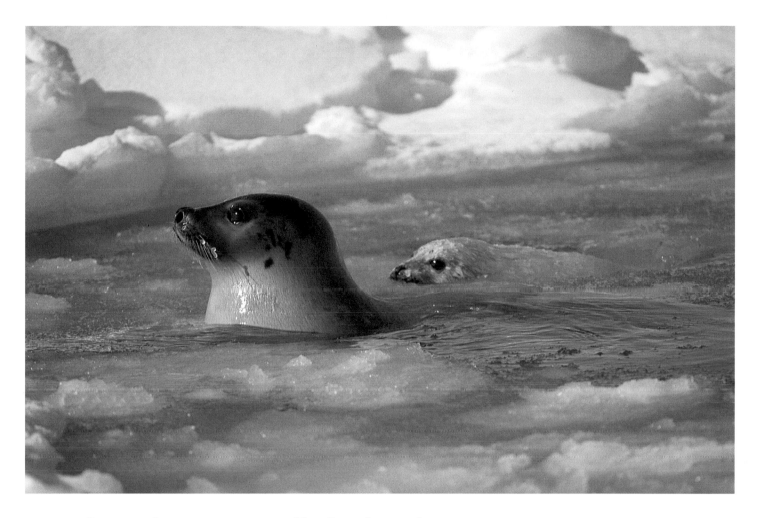

Pups have to learn to swim well. Their home for most of the remainder of their lives is in the water, since harp seals spend only four to six weeks a year on the ice. By the time the pup is two weeks old, it is weaned from its mother's milk and has to find its own food in the chilly waters of the Atlantic. The weaning is sudden—without any warning, the mother slides into the water between nursings as

she normally does, only this time she leaves forever, never to return to her pup. The two of them will always be part of the same seal herd, but the pup must quickly adjust to life on its own.

While the pups are being born and nursed, the males keep their distance, gathering in groups around breaks of open water. Once the pups are weaned, the female harp seals join the males for mating. The complete cycle of birth, nursing, and mating takes place in about two weeks, incredibly fast for such a large animal. In April when the ice melts and breaks up, the entire seal colony will join together again to journey back north to their summer feeding grounds in the Arctic seas. The young pups, having lost their fine white coats by now, will straggle behind the main herd, feeding as they go on small shrimp. As they grow stronger and their swimming skills improve, they will be able to dive and catch small fish to add to their diet. When fully grown, these harp seals will weigh up to three hundred pounds.

Home for the pups for the next few years will be in the North Atlantic feeding grounds, just below the Arctic Circle. The pups will feed, grow, and develop their swimming skills until they are old enough to mate. In their fifth or sixth year of life,

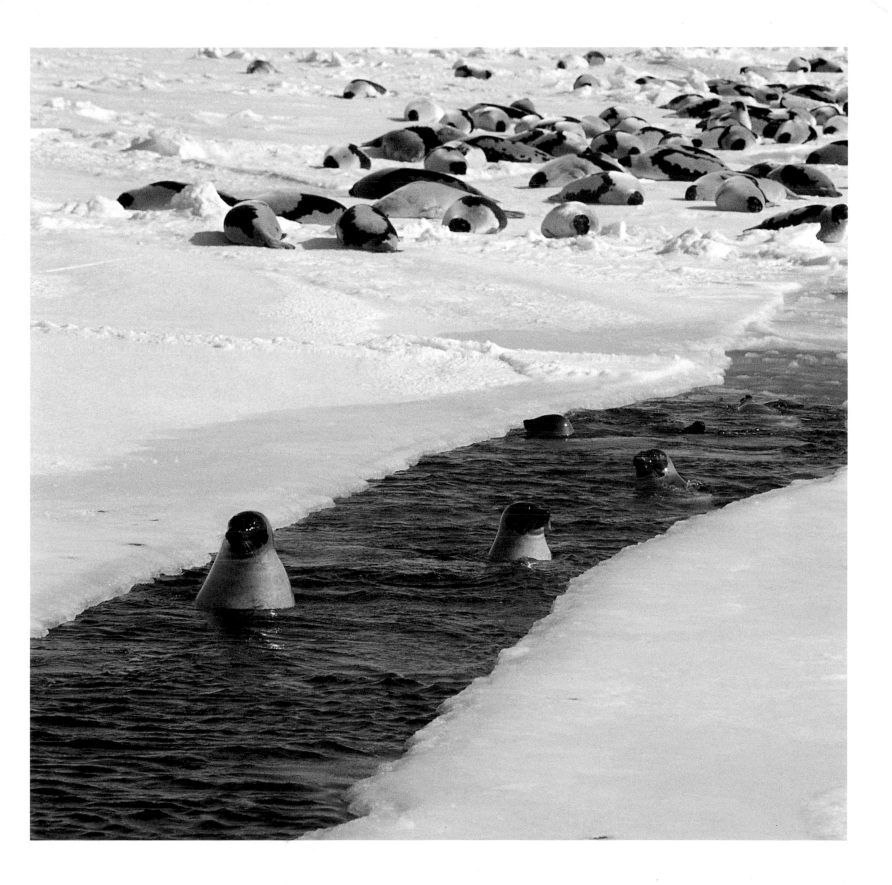

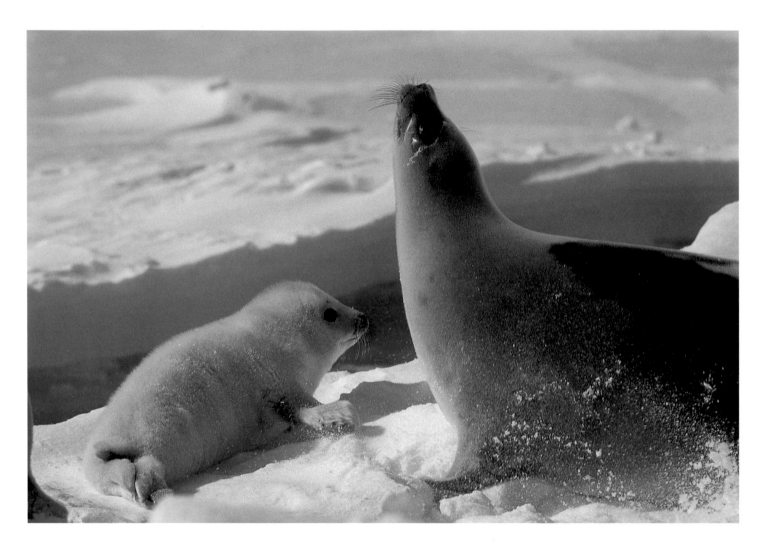

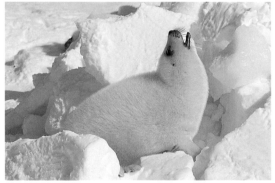

when autumn comes, they will know that it is their time to join the mature seals on the long swim south. Together, they will return to the ice where they were born. By the time that their lives come to an end, some twenty-five years later, most harp seals will have travelled over 75,000 miles, round and round through the ocean.

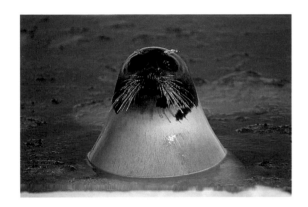

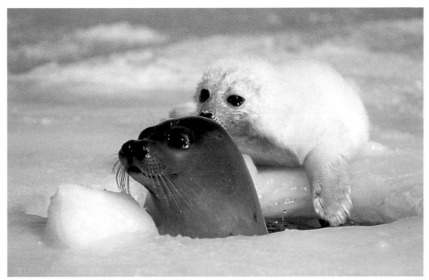

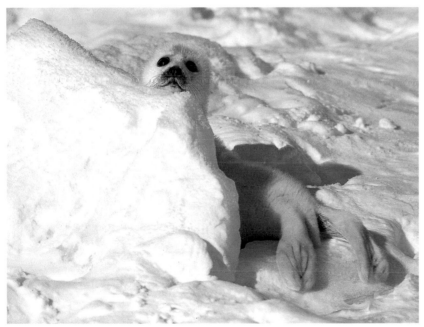

Jonah and I saw hundreds of seals. We spent hours and hours exploring on the ice. The sky grew dark in the late afternoon, and the pilots started warm-

ing the helicopter engines. Our day would soon be over. But there was still one thing Jonah wanted to do. "Dad," he said in a quiet voice, "could I please hold one seal before we go?"

We should have headed toward our helicopter, but instead, we walked in the other direction, over the long sloping ice ridge, in search of a friendly pup. There we found her—a beautiful whitecoat, round and contented with her first week of life.

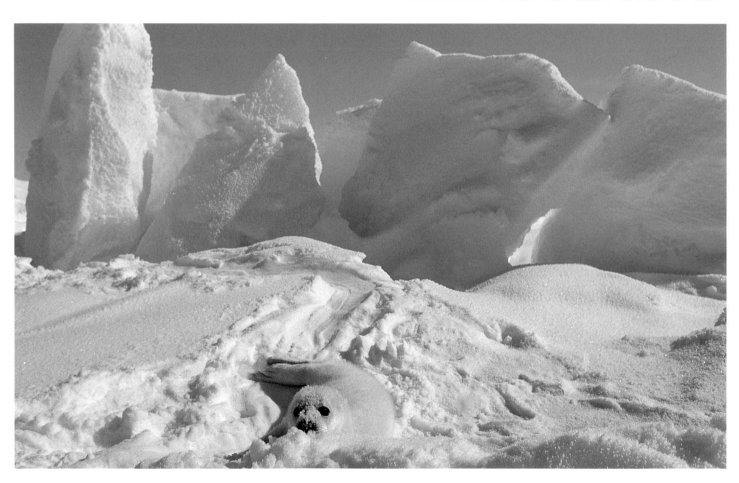

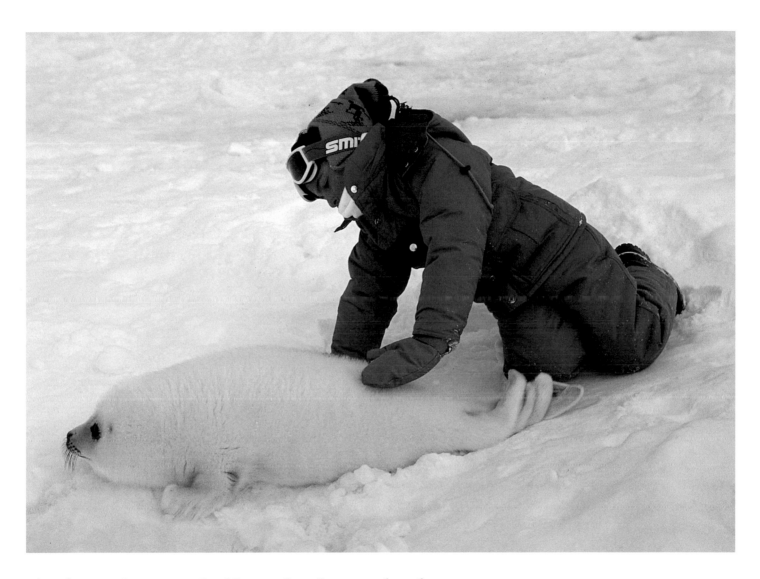

Slowly, Jonah approached her. When he was close he lay down to pet her. I went over and picked the seal up and placed her on Jonah's lap. "I can feel her breathing," Jonah said through the wide smile that now covered his face. "Her whiskers tickle and the soft white fur is like a warm blanket covering me."

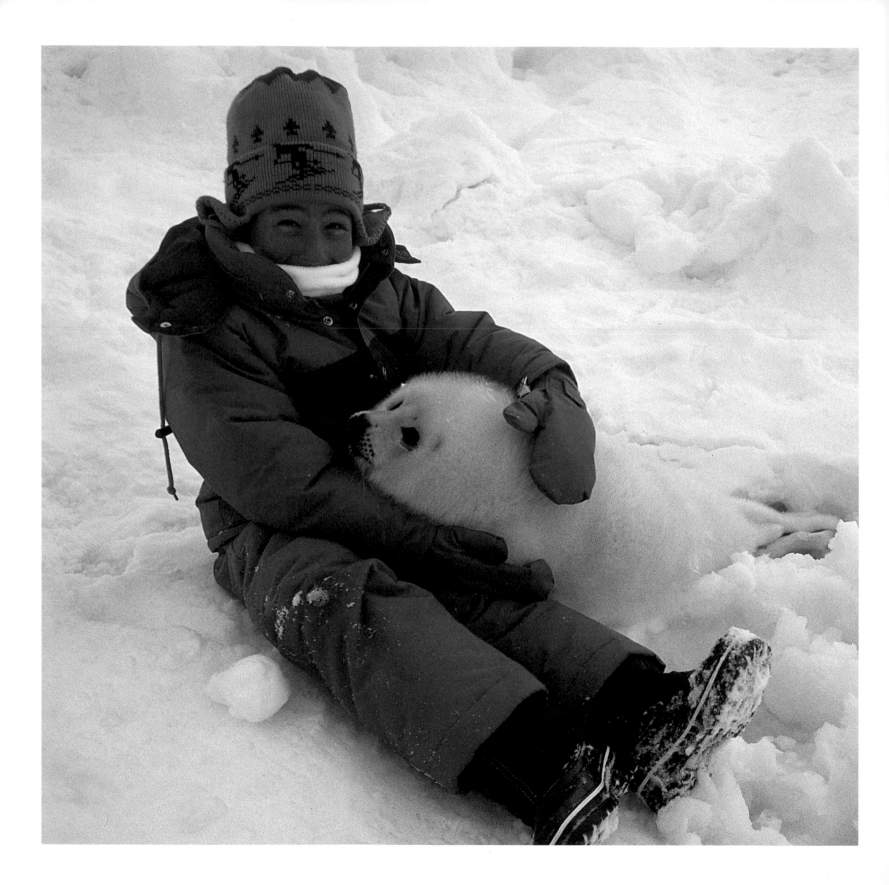

It is sad to think that this same fur was what the hunters were seeking when they stalked the ice to slaughter these seals. The fur that they stripped from the whitecoats was turned into slippers, gloves, and even dolls. For twenty years people who cared about saving the seals came out onto the ice to challenge the hunters and to make them stop. They let people throughout the world know about this cruelty and asked them not to buy anything made from seal fur. As more people knew what was happening to the seal pups they joined together and stopped buying seal products. The hunters had no place to sell the fur. Only then did the killing stop here. In other places though, some seal hunting does continue, as hunters still stain the ice with the blood of these lovely animals. These harp seal pups, born in the Gulf of St. Lawrence, are the lucky ones. Now protected by laws, for the first time in hundreds of years this seal nursery is filled only with the cries of the hungry pups and not the thuds of the hunters' clubs.

It was now time to go. Jonah gently put the seal back down and gave her a soft pat. As he walked away he turned back toward her for one final look. "Good-bye, seal," he said. "Now I know that dreams can come true."

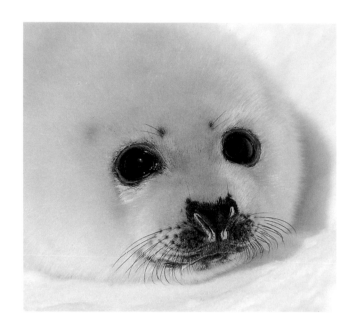

As we flew back toward Prince Edward Island and looked down at the ice, its sharp edges began to soften and the harsh white glare turned into watercolor splashes of pink and gray in the fading light. Soon the ice will melt and the seals will return north. During the hot summer months people will be sailing and swimming in this same wide channel. Next winter the ice will form again, calling the harp seals back. The magic of nature will bring more people here, too. Each year more and more adventurous tourists are journeying out onto the ice to experience the beauty of the seals. During these few short weeks people and seals can bring their worlds together. Somehow these seals seem to know that the people they encounter now are their protectors and there is no need to be afraid. This is how it should be.

MORE SEAL FACTS

Harp seals belong to the mammal group called pinnipeds. Pinnipeds are divided into three families:

Family Otariidae, which includes fur seals and sea lions, also known as "eared seals."

Family Odobenidae, which includes the walrus.

Family Phocidae, which includes all true seals.

True seals are monk seals, elephant seals, Antarctic seals, and northern true seals. They have rear flippers that extend behind their bodies and are also known as "earless seals." The openings to their ears are small holes on the sides of their heads

Harp seals are classified as northern true seals and their scientific name is *Phoca groenlandicus*.

Average adult weight—300 pounds

Average adult length—5½ feet

Average lifespan—30 years

Harp seals live in three areas in the North Atlantic—the east coast of Canada near Newfoundland, in the White Sea off of the coast of Russia, and between Yan Mayan and Svalbaard, east of Greenland. Estimates of world population today vary from 2.25 million to 3.5 million.

ACKNOWLEDGMENTS

Many thanks to the people who helped make this project possible. The staff of The International Fund For Animal Welfare for their assistance, support, and good humor in arranging for our travel out onto the ice: John Thorp, Richard Moore, Brian and Gloria Davies, Annameike Roelle, and David White.

Sharon Grollman for her help in the early stages of developing the story.

David Lavigne, Professor of Zoology, University of Guelph, Ontario, for his suggestions on the factual information in the text. I am endebted to his book, *Harps and Hoods*, for much of my research.

Steve Brettler and the E.P. Levine Co., for the generous gift of camera equipment.

Jimmy Colton, first as editor of Sipa Press, New York, and then as Director of Photography for *Newsweek*, and Gokshin Siphaglou and Phyliss Springer of Sipa Press, Paris, for their continued support and encouragement.

The Rugged Bear Clothing Co. for keeping Jonah warm.

Our helicopter pilots, Kevin, Mitch, and Telford.

The crew of the Greenpeace ship *Rainbow Warrior*, who first attempted to bring me out onto the ice in the early 1980s.

Thanks also to all who have been generous with their time and insight during this project: Caroline Thompson, Graham Nash, Farley Mowat, Jeff Aronson, Nicholas Fish, Joshua Rubenstein, Jon Slater, Betty Bardige, Herbert and Edith Sobol, Donald and Beverly Weiss, Rosanne Lauer, and Joe Budafudanucci.

Anyone wishing information on traveling on the ice to see the seals firsthand and participating in one of North America's most spectacular wildlife adventures, "Seal Watch," should contact: IFAW, 411 Main Street, Yarmouth Port, Massachusetts 02675.

R.S.